A Reality Revolution

David Domon
with Isabella Zumas

outskirtspress

DENVER, COLORADO

You're Welcome In

Before you start you must know
There is a depth through simple flow
For it was widened as I could
So that it may be understood
You must know your thought per line
To find your mind inside of mine
Then in these words when they are heard
You will wake to see the fake
Of where we are and what's at stake
So ask yourself every question
Put your life in every word
Live each page for just a moment
To give yourself a chance to see
A world inside reality

Learn to Know, Know to Learn

Do not know before you know
Know that you don't know, so you may know
Everything there is to know
Are you knowing something that isn't sure
You could never really be quite sure
That you really knew for sure
Unless you're sure you've felt it pure
Though if it's pure as you are sure
There are no questions to the cure
Of all those parts that seem unsure
Then what you can, you will know
Without question you will grow

It's Time

If you make yourself do this
You can make yourself through this
Into who you always were
Out from where you'll never find
Peace with yourself inside your mind
With all this light you're choking on
As you're holding thoughts floating off
Into the distance of older time
Without a footing in newer minds
Those older days have slipped a ways
From the minds of those who leave you
Into the novelty of darker days
Unless you find a change of mind
Then grab it tight just in time

Two Sides to One Puzzle

The good and the bad come as a pair
Both must be seen to release from despair
To view only good is to see just a piece
Of a puzzle that puzzles people to pieces
You can positively fit them into their places
Though soon you will find numerous spaces
Those spaces are places you cannot ignore
They belong to the negative dropped on the floor
You must pick them up to find where they fit
Or in constant frustration you'll find you will sit

The Most Worth

Loving takes much longer
To grow inside of life
Young love needs a harbor
From storms of frostbit nights
For if we never nurture
Those needs of our hearts
We lose ourselves to weathered lives
Without a warmth of loving parts
With patience as a moisture
Of tears upon a joyful face
That can wash away the pain
Those parts of life that need replaced

An Understanding of Love

To look out from behind
The eyes of another
Is to see from a place
Hate cannot smother

Imagine you thinking
There in the place
Of those who you know
In which you embrace

What is it you see
Looking into your eyes
Those very same ones
From which you reside

Do your actions agree
With words that you tell
To the one you're behind
Should they love you as well

The Truth of Dedication

A circling each other
Searching for the core
To find the revealing
Of that which we store

Our hearts locked away
From the pain and the sorrow
Of a life that was lived
With love that was borrowed

Though I am not lending
Though my love is not free
All that I ask
Be open to me

Know I may hurt you
As I will be wrong
Though know I will try
For a love that is strong

The Strongest of Two

If light is love and darkness hate
If love is positive and hate the negative
If positive is action and negative reaction
Act upon this
You cannot enter a lit room
With a darkness to put it out
The stars far away at night
Never let the black surmount
Only in our hearts it fights
Trying to extinguish our loving lights

The Road onto Love

This world is never perfect
As time will always tell
As understanding is the way
Into love of deeper wells
Where springs of our affection
Silently flow far beneath
Though we cannot draw them
Without rope between our teeth
As tongues pull the buckets burning
Communicating all that pain
That time continually is earning
It will always be the yearning stain
Of the expressive kept inside
That must be drawn for deeper love
Which quenches life's lonely ride
To create the road that goes above

Light the Inside

The work is worth it
Honesty is the road
Travel deep into love
Come alive with your eyes
Don't learn to love again
Let new love begin
Go further than you've traveled
Further than you've heard
Go to find the very end
Of where the light of love does send
But do not let them consume you
That is not what love is for
Find a fairness for yourselves
To find a love that does not die
Though make sure that you know
They hate you from the dark
And you must find their heartfelt spark

Brick by Brick

I met her where walls are tall
Just as she met myself
We worked through misperceptions
To that communicating health
Of telling harder truths
While making safer places
Where both could know a person
Without the other filling spaces
With words of need to say
To hide behind the hurt
That reason for those walls
We both knew had to fall
What we found to our surprise
You'll have to see from eye to eyes

The Path to Ever Take

There is a path through love
That joins at one understanding
Where only lies could tear us
Where only time would have us part
This path begins of action
Of our loving to refine
Though when it burns the brightest
You see the darkest sign
But do not look away
For the moment that you do
The darkness kept at bay
Comes right in to devour you

The Meaning of Life

Natural thoughts are a blossom
On the branches of society
Humanity extends its limbs
Upon the tree of all you see

Every human has a purpose
To let itself be true
To fit its natural function
Upon the limbs we break through

Every fear kills a blossom
This is why we never find
The meaning of our lives
Inside the branches all this time

Clarity's Hope

If you believe life can change
All your pride must rearrange
A letting go of what you've built
To build again on different times
To live again from different minds
If we could leave this mess behind
Forgive ourselves of all our crime
Then turn our heads away from being
Closed off from what we're seeing
If we could see the eyes of others
Would we recognize our mothers
Would we notice all our brothers
Who fight all day for what they've built
Who see from places that have begun to wilt
If we believed life can change
Could all this world rearrange
Into a place where we would know
Just how scared we are to show
That fear of others that would not be
A reason for the hate we see
That chokes a world where we can find
Peace for different kinds of mind

Remembering Seeing You

Youth caught up with me
In the oddest way
It ran up from behind
Rang into my mind
As I ran to the bell
I remembered so well
How it felt to breathe
How it felt to feel
How it felt to think
About something real
How it felt to see
That all of humanity
Was just like me
Searching for answers
That we just couldn't see

Who You're Not

Stop that worry of who you're not
How you're seen or want to be
You become who you're not
Inside the who you're not
Do not let yourself forget
Being who you would be
Without a worry for who you see
For all this time you've always known
The who you are isn't who you're shown

Make Over Be

Do not be happy
Do not be positive
Don't be fooled

When it's not true
You don't feel it
Inside of you

Do make happiness
Do make positives
Do not be fooled

Action is necessary
To feel life improve

Knowing's Not Enough

What is it to know
Without making a move
To apply what you know
What does it prove

With the lack of an action
Can it really be said
The knowledge you're keeping
Has helped in your head

Or is life still the same
As it was in the past
Before you knew answers
To improving at last

This Book to Experience

The more you apply
The more you will see
You don't have to figure
You just have to be
It cannot be figured
From inside of a trap
You must take a leap
Off of the map
To see that awareness
Is a place to be traveled
To views you don't see
That your eyes will unravel

Walk the Talk

You must walk
What you talk
To find what
You can't tell
What you want
All this time
Is to walk
What you talk
What you want
All in time
If you try
You can find

Balance Out Talk

Too much talk inside the past
Spending all your time inside
You begin to freak then slide

Too much future has not been
To talk too far you never see
All that time might never be

Make a stand to use your time
For the now, the bottom line

What Perfect Is

Is perfect the only way
You enjoy any day
I'll let you in on perfect's fray
It isn't real, it doesn't stay
Very long on any day
Never really in any way
What you search for isn't real
Perfect peels once it seals

Imperfectious

Search for the perfect
Find what you're not
Then throw it away
With the rest of your thought

That doesn't line up
With anything real
Find what you are
To fit what you feel

Through Admission of Fault

If you're never wrong
You're probably never right
About how to know
Many things you might
What is there to know
When you're never wrong
What is there to talk about
When you know you use
Lies to hide the truths
This approach will never work
When it comes to living life
All it does is choke the point
Of hope in any fight
Because there's no progression
You live inside a blinded sight
You're seeing through your eyes
Though never seeing light

The Work Around of Lies

All our lies work around
What we need to say
Though if we'd tell the truth
Our world would change in a day
How weird to see our work around
With all the effort that we've found
To bury problems in the ground
Which never do decay
We've got to dig in deep to tell
The truth we need to leave this spell
We've got to find we work on more
Than putting problems in the floor
For when we try to stand up tall
We always find we slip and fall

The Point to Change

Nothing comes of arguing sides
If not around a point
As points are rarely reached
When sides cannot be breached
For the breaching of a side
Is how to stay on point
Once one folds in to lose
You know their side they abuse
For to hide behind a side
Is to reside beneath a lie
As motive lies just beyond
The point that side had not gone

Out of Sides

Have you been taught to take a side
Then given none to take
Have you been taught it's A or B
With A or B being a mistake
Thoughts must travel out of sides
To realize the game that slides
Right between our brain and eyes
This blinder binds a world that is
Much too complex for sides to live
A mind of sides gets stuck inside
The show for eyes to lose the ties
To that real outside of sides

Born to a House of Mirrors

Everywhere we look we're took
Into fun mirrors eyes do fall
Unto the game designed for all
That keeps us staring down a hole
That never throws an answer back
All it does is leave a lack
Of a story we know is real
In those times we know we feel
That all we see are spinning wheels
Though not far beyond the twisted views
Exists the mirror straight and true
Inside its knowledge minds are free
To balance views of all they see

Fast Is for the Physical

Thinking fast is thinking past
What there is to see that lasts
It isn't felt from fast or slow
At a pace you see it show
It opens up without the race
This running down an impossible pace
That you never find you ever win
It isn't worth the time you spend
In the end you'll find that fast
Will steal the life you're running past

The Why of Not Fast

Precision is faster than speed
If put into its place
Precision jumps right over
Running fast lost in space
When a mind's directive's lost
Going toward a goal unknown
It's then we're going fast
While not seeing the life we roam

Deceptive Time

To think on seconds
To ponder the minutes
To waste these hours
Inside the haze
This fractioned cycle
It baits our mind
To fit into
These busy times
So much so
That we've forgotten
What it was
To feel a day

A Natural Connection

Fed by nature's open spaces
The beauty lies between the traces
Of fleeting moments everlasting
From slow enough for eyes to bask in
Once these moments find your mind
Letting go is to find you're dying
Losing connection with the mother
Is to forget where life's a lover
Never would I leave her side
Addictions set too deep to hide
To break this habit would break me down
Then bury a mind that I have found

Seed to Tree

Delicate in the hand
Warm and moist in the land
A seedling grew
Reaching for the sky and every day anew
The sapling grows in haste
With need to live and to die
Not strong enough for the wind
Yet tall enough to see the sky
Now a mighty tree
Who's seen the drought and frosted leaves
So how was it to grow
If spring was not to flee
How was it to root and become a mighty tree
With no want or need
With no need to plead

A Second, a Minute, an Age, or a Day

All of us here caught up in a sway
We love in the morning and hate in the day
As we self-prescribe for aliments unseen
In a time for exactly what this time would have been
Then we cry when it's dark that we want to see light
It shines in our eyes as we use all our might
To turn from the dark to walk on a path
With bright in our eyes and love in our laugh
For smiles we find as we walk down this road
Though time after time it has showed we are slowed
By a want to be freed from a life so controlled
By the want to reseed a dark that is bold
We're all of us here caught up in a sway
In a second, a minute, an age, or a day

The Brighter Side of You

I've seen the loving out of you
From the child's side
A view of inside each of you
A part that has not died
You still gift me foolish hope
I've received it from your eyes
I know a love still exists
In that heart beneath your pride
If you would only let it out
To see the light of day
The entire world would change
In every single way
Instead of racial tensions
Instead of warring classes
Instead of forced conformity
Would we see the loving masses

What Is It We Know

Different people live different lives
In different ways on different days
For different reasons all the time
The sum of your thoughts is one point of view
Floating around in the consistently new
View of it all from each set of eyes
Viewing it all without seeing the prize
That hidden inside is a truth seldom seen
In each point of view is a difference in being
For from different families we rise
Into different cultures and times
With thousands upon thousands of views kept in sight
All put together in the history of who
When each individual is different from you

See

A view from inside out
To views from outside in
Where these two overlap
Is where we all have been
Thinking that we see
Thinking that they do
Not knowing that a point of view
Isn't you looking at you
We must grow past this state
Of mind that is not true
It's not the other side
It is up, it is out
It is open, it is onward
It is free, it is to see

The Water of Waves

All of humanity stands in a pond
With a single action a ripple has gone
It travels out to hit many others
Their ripples all leave then society smothers
You're standing there thinking your hands are dry
Though you are wrong and living a lie
Every act matters regardless of size
For when they're put together
Our tsunamis do rise
As we crash on each other
We are turning the tide
Toward the light of our love
Or the pain of our pride

Hope to Free You

Minds running over all they see
Skipping thoughts as skipping stones
Which never into surface sink
Of anything that they think
Brains rushing over standing waters
While never pondering any deeper
Than what their minds are taught to link
Inside this system of stunning blink
Those tiny lights that lead with sound
To never let the mind around
Then out to see what's going on
To that not seen flowing under
All they view that's going under
If this running included sight
Minds could reach, I think they might
Find their way into the ripples
That shed a light on mind controls
Then on to filling all the holes

The Natural Spill Away

Only minds that open catch
What there is to gather
Only willing minds will fill
With what the close-minded spill
That which died before is running
Like warming ice into the spring
Overflowing the old ravine
Unto the plains of open thought
Carving paths through the snow
Without the fear that freezes solid
The virgin ground will overflow
Unto the deltas of the brain
Scoring thought as streams remain
Running through the freshest time
Turning an age to leave behind
Those churning answers to older quest
While questions arise to create unrest

To Those Inside Transition

You are something that will not crush
The world is yours, stand your ground
In togetherness you drag it down
To turn it in then around
Resist the greed they feed to you
Possess your minds instead of things
Find the ways to turn the tides
For you're the wind to fill our ways
True to yourselves you must stay
Do not give in to the bitter end
Of all your dreams of light and love
Know they're falling from high above
Know you're stronger with every number
Count me in for something new
I am standing next to you
We will see this transition through

We into Me

Say we with me
I
Just won't do
It doesn't work
Us
Into you

Why We Get Nowhere

We were taught
To take it all
Then we were taught
To take a fall

They put in you their reasons
To fear being the only one
To hear yourself then respond
To yourself then move on

Big Talk

All they have us doing
Is talking really small
Too scared for real opinions
Too scared to move at all
Afraid of being out of place
Afraid of not fitting in
Afraid of talking bigger
Than the small talk that we're in
We've been scared into it
Over a period of time
Now we don't ever talk
About getting out of line
Though if you stay in it
Small talking as you do
They'll have you talking small
Until you're old and blue
Wishing you did something bigger
With the life you never knew

It's Not You

They just don't care
Though if they do
You should not care
What they think about you
For if you knew
Just who they were
You would not want them
So why do you stir
When we are all here
Just living along
Not caring about
Where you go wrong
Please live your life
While not looking out
For so much approval
You won't find about

Artificial Unintelligence

We are smart once we think
Though knowledge is hidden behind a blink
When our eyes begin to open
The best of knowledge slides behind
It's slid around under a cup
It's not inside this game we sup
Put out of place by those who know
A sleight of hand controls the flow
Of knowledge that we need to stow
For this time of guiding light
That opens eyes into sight
Though artificial is all there is
As most the people blink to think
When what they really need is sight
A light to see behind the fright

Robotics

We're so serious about playing life
That living life gets ignored
All that time spent being right
With every move made so tight
Then right on time at every turn
We're burning rubber but never parting
From a life of programmed paths
That get us through robotic days
So deep inside robotic ways
Far away from any feeling
Even further from life with meaning
We start to feel our life depleting
But there's no shame when you were taught it
So just let go of the robotic

What

What happened to work
What happened to you
What happened to me
Hey, I'm awake
There's more I can see
Stepping back from my eyes
And to my surprise
Where I was at
Was neck deep in lies
There were lies of my own
There were lies in your eyes
There were lies on TV
There were lies between ties
Of the people I saw
As I looked all around
Awake in the open
A mind that I'd found

Divided by Content

So what do you do
When you're miles away
From the people you're with
Who speak the same language
Though have nothing to say
While they're locked in a system
Where they're taught not to see
That their freedom's restricted
By what they all need to be
By what they all need to think
By what they all need to do
To fit in said system
That I'm already through
As I stand looking back
Trying to show you a way
To get out of a place
Where we all shouldn't stay

Lend Me the Ear of Your Brain

Please may I talk you
Into saving yourself
Please may I talk you
Out of a trap
Please may I talk you
Into a map
Please may I talk you
Off of their course
Please may I talk you
Into walking away
Please may I talk you
Into leaving today

Intent

As I look out to those
Who sleep in a dream
Masses of people
Caught up in a theme
Where minds have been closed
Behind all those lies
I'd love to expose
To free all their eyes
So they may awake
To uniting together
Then come into foresight
To notice the weather
To see the wind blowing
Then react to our knowing
The truth that we've lost
Is not without cost

You Hold Your Key to See

Your own mirror is first to see
Without this sight light can't be
So gather up what you know
For a sum of truths into one
Do not ever stop this
For every day you're never done
For to change for the better
Is not a weaker sign
It shows that you are learning
That you can change your mind

Though Most Must Have a Grip

Imagine what it would feel like
Taking history by the horns
To change the course we're on
From systems old and worn
Imagine what it would feel like
To place us on a path
That led to greener pastures
Where minds could love and laugh
Imagine what it would feel like
Once we'd come to see
Our actions of this time
Improve the course of history

Human Search for Balanced Answers

Our bouncing mind is like a ball
Down a hall from wall to wall
From one extreme to the next
We hit a wall then reflect
As we consider the place we missed
We act too quickly to bounce our ball
Straight on back to the other wall
Though we don't see our hallway narrow
For in each time we hit the wall
We should learn something from our ball
Though if we would slow your bouncing mind
To see both ends at one time
In that moment we'd hold our ball
To view a middle of the hall
Then as our minds find direction
The world is open to our inspection

The Undefinitive Answer

The reason for balance
We are split into two
Straight down the middle
Of brains that we grew

One brain that we have
Is made of two parts
The balance of two
Is from where to start

To fall out of balance
Is to see from a side
Which is only a part
Of a triangular ride

Within constant searching
You find that a middle
Is lost to a time
And is not a riddle

The Discipline of Balance

The constant balance
Of your brain
Will make sure
You are sane

If you feel
You're falling off
See both ends
At one time
Search the middle
Inside the mind

Into balance all of you
Balanced minds are never through

Believe in Your Brain

When you feel that thought beyond
That you felt but went away
Trust you are thinking on it
With every single day
If you continue on that path
It will continue to the other
To show that you are learning
Then trust you'll find another
And then many others

Brains on Fire

Nothing's the matter
With your brain batter
Just bulbs illuminating
Creating a fading
Of ideas incomplete
Where paths did not meet
Igniting the black
Inside of your heads
Expanding the banding
Of electrical landings

Behind Your Seeing

You're piecing it together
You don't even know it
The brain adds it up
But you always blow it

You've known the correct
You've felt it connect
But right was too different
As wrong was erect

Just let yourself go
To do what you know
Was right all that time
Inside of your mind

Knowledge Always Learns

I was wrong years ago
Then I was wrong last year
Just as I was months ago
I've been wrong in my fear
I will be wrong today
I will be wrong tomorrow
Though one thing I'll never do
Is let my pride steal the new

Knowing Feels Good

When going through times
We all go through
I get through the day
Not feeling so blue
By one little feeling
That keeps me alive
Knowing feels good
So deep inside
Knowing the why
Why did this happen
Why did that not
Knowing life sways
From good into bad
Then back into glad
Knowing that truth
No matter how sad
Is better to know
Than be blindingly mad

Running Though Not Away

The finest line lies in between
Figuring it out and worrying
Too much time is wasted when
We think of problems though never begin
To find the break for the bind
Before repeating thoughts of why
When how is clearly the closest step
Away from worrying into walking
Toward the problem you are stalking
How to fix or how to find
The way to see a problem's dying
Before the problem begins the hunt
Of dear old you who finds a way
Back to running toward worrying today

Fight Not Flight

Clench your fist for a fight
That you don't know you're in
Every day it beats you up
Though all you do is give in

Why not find the might to fight
To let your brain dig in
To throw a punch to meet the punch
Of all that worry flight throws in

When you feel it run away
You'll know that you have won
For you did finally learn to fight
The fear that kept you on the run

That Digging into Pain

Why go digging in the past
When every time you look to see
All that pain won't let you be
You dig so deep to never find
Any answers all the time
Tell me when will you give up
Then start to see you find the time
To hide away from right now
Inside your past which never answers
Any questions all this time, but why
You can't go back to that time
Your brain won't let you kill your mind

Memories of the Future

Don't look to the past to see it
When it shows up as you're going
Those parts you need are waiting
Those memories are never fading
They wait for you to learn
So they can come to you
To show as you confirm
As you're learning something new

A Life of Now

Let the distant future do
What the future does
Let the past be
Everything it was
Living in the now
Is all there really is
A mind inside the now
Is where your life is lived
If you think along these lines
Then on these times you'll go
Into a life of every day
Inside a mind that flows

A Necessary Exchange

Something always gives
Just as something changes
Everything is soon to change
For change is falling down
It has you trapped it's all around
You have to go right through it
Without the fear you hold
It has you chained to blew it
It has you growing cold
Let go of the oppressive
Let go of what they'll say
Live your time right through it
In every single way
It's time to break right open
It's time to come alive
It's time to hope again
It's time to lose your pride
For something always has to give
Just as something changes

Redirect Consumption

There is no purchase for the price
There is no cost for what you've lost
It can't be bought that which you've sought
Only sight can set you right
As only light will fill the fright
Of empty feelings that you avoid
That never leave your mind at ease
They're always there a painful tease
They pull at you until you're down
Now they have you on the ground
So will you sink into your ship
Or will your mind break to flip
Then come around to making sense
To breathe again from different lips
That kiss the life you've always missed
From all that time inside their lying
You've been dying but there's a sign
That things can change inside a brain
That we can leave behind this stain
To live again without this pain
To see again from open eyes
To feel again a love for life
To cry the tears of hope once more

While free to live, while free to love
While free to see, while free to be
As you're awake and talking
While down the road of truth you're walking

What It's Not

All day long it's what it's not
That's all we think
It was their plot
So they can keep you
Buying, buying, buying, trying
To satisfy the what it's not
As you go back to watch a tube
To find again what you're not
So they can keep you
Trying, trying, trying, buying
That all day long they aren't lying

You Say You Want To

Fair replaces selfishness
If you would like to get away
Put fair in its place
And fair will save your day
You won't always have to win
You can stop then learn
That fair will balance you
And respect you will earn

The Unnecessary Suffering of Selfishness

To find the selfish to survive
It seems to make some sense
That fighting for a better life
Keeping oneself from the strife
Though when does selfish go beyond
The point of useful action
When does selfish start to stink
Of those greedy self-attractions
How much dough is really needed
Just to eat the strife
How long should one watch them suffer
If selfish makes the poorest buffer
For you will feel the tears they cry
Once all is said and done
No one will be at your side
If your care was just for one

Alone Together

Selfishness is in the way
Of everything to feel
It's like trying to connect
Though nothing's ever real
Selfishness was in our way
Of anything we could have felt
It's like trying to know someone
Though all you know is what you've done

So You Want to Be a Star

They do it for a living
You do it for a life
The stars you're looking to
Are the wrong kind of light
As you're falling flat
You find you're on your back
While trying to be a star
You're bloating like a cat
That fell off the walk
After climbing on the walls
Then finally it happened
You got run over by the malls
Just get up off the street
Look to yourself to meet
Then shine a light to see
That you were always free
To be what you could be

The Maze Inside Your Mind

In front of every door is fear
It locks you into blind
You're covered in it ear to ear
It's poisoned all your mind
The door to solve your worry
The door to stop the crying
The door to fix the blurry
Of who you are inside
There is no riddle to it
There is no mountain climb
There is only finding out
Fear is what has you dying
And all that there is to it
Is standing at the door
Reaching out your hand and turning
What you had not before

Fear in Doubt

Work it out, see it clear
Write it down, spell them out
All the fears you keep about

Steer away from looking down
You bump your brain on a mound
Of all the detail you don't know
About the fear that keeps you low

Raise your head, look around
Find your fear, put it down
For a second just to see
If all your fears need to be

Then once you've found
A doubt in fear
Every day you must try
To tell your fear exactly why
You no longer fear its face
For you've put it in its place

Evil the Puppet King

Who is evil really
How bad could he be
Why is he so scary
If evil lets you free

He hides inside every day
Around a corner casting spells
Though you don't ever see him
You just assume he's mad as hell

Then what is evil really
In life from day to day
He really seems quite silly
He finds the time to slip away

So why does evil do it
If he'd rather go and play
Who has evil by the balls
Who makes evil take his calls

A true master keeps him chained
He's right before your eyes
Evil's job is turning heads
Away from seeing fear disguised

Save Me from Your Eyes

It is never too late to change
Something that's been bad for a while
Do not run away from your life
Now is the time to smile
Remember those days of your life
When you found nothing but smiles
What if I told you you're in denial
I know how you feel
I had been in it awhile
All I remember was day after day
Believing the world would someday change
Then all my life would rearrange
But then I found that I had died
And I was living it alive
I know you're out there crying too
Let me help you into the new
Change all your life, live for today
Do it now, do it please
I've watched you suffer, I'm on my knees

Explosive Change Crisis

Once you have seen your life
Then find that you're to blame
For most of the shit then all of your shame
Refrain from hanging your head below
A place that change cannot go
See your faults to be your faults
Then once you're ready to let go
Forgive yourself because you change
For time gets older as we age
If we become who we were not before
Let it go then close the door
If going back is to see your death
Then moving forward is all there is
Changing everything is gasping for breath
While you're drowning inside the darkness
Of what you have done in the past
Go forward from here away from the blast

Hope Is Light's Direction

The less of it there is
The more of it we need
The less of it we see
The more we feel we bleed

Walk With Me

Pick yourself up
Every time that you do
You walk from a life
That turned you all blue
Pick yourself up
You'll never regret it
Pick yourself up
Then do it again
You'll learn to walk
If you pick yourself up
So pick yourself up
For all that we do
Is make those mistakes
That we never are through
So just pick yourself up

The Ongoing Nowhere

What are you waiting to live for
What if it never comes
What if waiting doesn't stop
Until your life is done
Could you say you lived it
When all you did was try
To get those things you wanted
As your life just passed you by

If We Knew Would We Do

A directed finger pointed
At the people through the masses
To the ones who made our lives
Full of strife not full of strides
A potential crossed in this crime
Ideas we lost keep me sighing
Who could humanity have been
Without Bernice, who locked us in
What if human minds were freed
To shape a world where all assist
With current knowledge we can't resist
Imagine if we really knew
All the better things to do

Honest Ground

A feeling of falling from another
Our running out into trees
We're climbing far from ourselves
So we don't feel the tears we squeeze
We're hidden high into the tops
Speaking from behind our props
This is who I want to be
Though it isn't really me
As it's really plain to see
We're all different and just the same
Behind these props inside the game
We hide our person from the pain
While never speaking of the fact
We can't heal behind a mask
So problems then begin to stack
Up into our trees they follow
Now we've begun to feel we're hollow
Once we see our trees have died
We must quickly swallow pride
Come on down from hiding places
Onto the ground of open spaces
Then talk together just to see
That truth in word is all we need
To finally find an honest ground
So we can tear our problems down

The Flight in Search

A natural state of being
The meaning of our lives
Not the state we're seeing
Believing in our pride
Lost inside disguises
Not the self inside
All we do is hide it
Underneath our lies
Yeah, I'm doing fine
Yes, I like my life
But back at home in my bedroom
I want to end my strife
Will this system kill me
Will it take my life
There's no room to fill me
I'm like a bird at night
A natural state of being
Is my intended search
When I fly unto it
It will be my perch

To Love to Cry

We must force our hand
To face our pain
To put a finger on the blame
To arm ourselves and trust again
The foundations lay before our knees
That we may crawl to find our keys
Unlock the doors that we're behind
To see again for we are blind
The cell we're in is all alone
When someone calls no one's home
Times so dark and oh so dim
Those tears we cry just fall within
A time has come for us to die
Though we're not ready to say goodbye
So though we fear we must try
To find a way to love to cry

Eating Pain

Eating the pain of your mind
Eating the pain of the muscle
Dodging pain never gains
Strength a mind can retain
You've got to admit to the hurt
Inhale the fact you're weak
To exhale the pain you feel
Then build on time into real
Where you see a simple equation
Of needing to see from two
The positive side of life
And the negative that isn't new
As it gets you stuck inside
You're running out of room
You've got to let it happen
You must consume it before it does you

The Contradiction of Beautiful

With eyes you see them
You want to be them
Beautiful has a hold on you
Hypnotized in all you do
Beauty shines upon their face
All their features in their place
Legs so long, eyes so blue
Hair so right just for you
Though because you see
With only eyes
You're bound to fall
For beauties lie
Seemingly it is true
That beautiful is beauty too
So willing to ignore your ear
That you limit what you hear
Though to see into the heart
With your eyes you have to part
As you listen to within
Beauty's lie begins to thin
Then once you see they're ugly too
As beautiful sets a hook in you
You'll begin to understand
That pride makes ugly of within

Women Kept in Blue

Every day her eyes are told
She doesn't fit the mold
Legs aren't slim hip to toe
Breasts aren't saying hello
Arms aren't muscle or bone
Butt doesn't stand up alone
Where stomach is her belly shows
Every day her eyes are told
She needs to buy what she's sold
She doesn't even own a dime
She's five years old and now she's crying
From this day on she's lost her way
They've locked her in, she's there to stay
Then time goes on then babies cry
She forgets the what and why
She dresses her all in blue
It starts again, it's up to you

To See Women Fly

Two are one inside of you
We are never less than two
This is what was missed the most
In this age of the masculine boast

If in our age we had a stage
For woman's rage at her cage
She would be next to man
Though holding life in a hand
If she could breed the evil out
She would stand with much more clout
For now she has a choice to stand

So choose a man you know is true
As he speaks of love to you
Read his actions to weigh the proof
See him know you or let him loose
If you love him by these words
You'll all be free just like the birds

From Free of Expectations

A wedge has been driven between women and men
It keeps us apart then hurts every heart
A woman is told that she isn't a man
She is lost to a chase that isn't her race
A man he's been told he isn't a man
Unless he's a rock with his love in a shock
How can we live with this space in between
When all that we want is love to be seen
Why do we fake as if love we do make
When we can't connect from a place where we face
If only our minds were to meet at our eyes
We would see the same love without the disguise

Ending Mental Trending

A trendless population ends
An oversight of our minds
We're fit precisely into trend
So we don't get out of line
Or if fitted for a trend
They don't want inside a mind
It will be muzzled in due time
This is how control is played
We walk right into what they've laid
Then knowing that a trend can end
We're fit into it as we bend
You're bowing to it once you trend
So if you'd like this not to matter
Create a trend I'll watch it splatter

Multiple Choice

Living a life of multiple choice
There are trends to be filled
With the multitude's voice
Though who makes the choice
For all of that voice
What is it we follow into hypnosis
Who's in our heads making the pillow
Closing our eyes into the mellow
Turning our brains into jiggly Jell-o
Where minds never desire to fill in the blanks
That fit in between all of the ranks
Purposely made to catch every mind
Into the webs of trend we are lying
Put into place as needed to be
For choices that lead into machines
Which run the whole country into ravines
Too deep into dark to see any light
No need for a trend to feel for a fight

Your Beautiful Inability to Fake It

To all of you with heads hung low
With eyes disguised in naked lies
Ashamed of who it is you see
Not fitting into what to be
That to be it's not for you
They make it for a selective few
In this society of fit or fail
That puts the coffin in the nail
Of the anchor that keeps you down
For being you without the sound
Of filing in to fill that place
For all of those so willing too
Never be as strong as you

Pretending Life

Losing lives we're supposed to live
Living lives where we pretend
Being someone who we're not
Living lives that we don't want
Though every step we take away
From that person we display
Inside our minds we can see
That living right cannot be
Inside of lies we cannot see
That do not lead us into a life
That we live without the knife
Which we use to cut away
Those parts of us that we don't say
Are worth the pressure to display

Eyes Spied

When looking young is being young
You look through older eyes
Into a mystery far beyond
A somewhat older mind
Looking young then being young
Is lost within your time
Inside a car, a shirt, a bar
Or trying to look like a star
Though in your eye a star is not
For in your eyes are age and plot
Because you're old looking young
You fail to hide the mind
For it has never really known
That thinking young is looking young
As years express through the eyes

Dislodge Humanity

Once we say we can't, we don't
Once we say we can, we might
Once we see a future light
Any path to seeing will follow
Into freedom from that swallow
Lodged inside the throat of beast
Eating people as they feast
On our future state of mind
We're broken down over time
Then can't find a trace of light
We start to die of our fright
Of uncertain days of lesser possession
In certain death of harmful obsession
Once we claim we will, we can
Save that light inside our eyes
Before they take it with their lies

Toppled Off

How much tighter can we wind
It's there to see all the time
It all comes out in the way
We say those words we have to say
As we shape our words into being
Exactly how they need to seem
For each of us to fit the top
Spun around and about to drop
To do all this just to fit
Into place but out of it
Seems a way to surely die
To lose ourselves then lose the tie
To who we are before the choice
To change our words then our voice

The Production of Mimics

One of a kind
If you let yourself be
You're one of a kind
From all who you see
You should be special to you
For you are special to me
A piece of the pie
Inside everyone's eye
Affecting the whole
Every time that you stray
Far away from the feeling
Of needing to play
That part that you plead
In that play which you stay

Out From All the Lies

Our minds were put into lines
Of thought that was not true
Enough to help a mind define
What it is that it should do
Our minds put there into lines
With thoughts that leave a clue
To what it is a mind can find
Inside the questions of the lying
Our minds can find all these lines
If in this time we can refine
How it is that life's defined
Without the need for clues

From Behind the Screen

Mammals stuck inside a tube
A funnel for human eyes
Straight into all those lines
You fall into their prize
The dormancy of human minds
That cannot feel to find the signs
That connect all those times
That tell a story of land mines
That minds walk into over times
That seem repeating but are not
When all the people have a chance
To funnel out then take a stance

Watching Into Circles

Those commercial breaks are breaking you
They go into you every day
Every time they hit your eyes
They put in you what you despise
It's what you're not and will never be
That keeps that feeling so alive
The feeling that you want to strive
To buy those things that make you better
Just long enough for you to live
Until their newest message gives
As you give in to what they spin
To only go around again

See See TV

Captions closed hiding our eyes
From their deceptions into lies
Freedom restricted by the ties
That people find within this time
Of lost inside a network's mind
So how is it we'd ever know
That truth we'd find inside a show
When even news creates a doubt
That truth could ever come about
In television we should not trust
For in our minds controlled they lust
If we could disregard the flack
To give no weight to their attack
In our mind a truth could stand
Then we for truth could find demand

Don't Go Back to Your Usual Programming

Unusual usage of an honest word
Programming does what you heard
With all its function in your head
Keeping you down to not quite dead
In this is where we learn to see
Exactly who we need to be
To sit into a life that fits
Inside a system that benefits
Those greediest rich at the top
Who wash our brains with a mop
For now they've got us on the floor
Under their foot begging for more
Oh, what's that next, master, sir
Close my eyes to make a blur
That covers truths you're trying to hide
I am not sorry and won't abide
Forever light will fight your tide
Until that day your grip has died

The Grow Over

You're getting stuck in Euclid
When there's a world to see
You're getting stuck in preschool
When you're watching that TV
It has turned you into toddlers
Of the grown-up kind
It has robbed you of your brain
And now it stole your mind
Once you're ready to expand
Past the screen you'll see
There's much more room to life
Than what they're telling you to be

Open to Question

Not all Knowledge is created equal
As to learn does not always lead
From where you are to where you need
For when to pick up any book
Is to into Knowledge look
Then where they lead can go astray
If not careful to see the way

Seed Doesn't Satisfy

Running around without the right head
Planting seeds instead of bread
Why would one decide to seed
Could it be that they're scared
To show the motives that they bear

Into the mind the seed does enter
It floats around into the center
If you find you are not aware
Seeds will grow into your stare
As your eyes look all around
Ideas are planted that keep you down

What is the difference of seed and bread
Bread tastes clear inside your head

Those Beautiful People Who Eat Fast Food

Look to find what you are told
Is it true what they have sold
Into your eyes they put lies
Of curly fries that don't add size
Their die it Coke is no joke
With their figures they do poke
At all that fat they put there
Just to keep you so aware
That you're in need of diet despair
Around and round you will go
Until they have you in a flow
Of hating who it is you see
In your bathroom as you plea
While wanting to look just like them
Those beautiful people who eat shit
And always seem to stay fit

Drink Water

We are Bagdad batteries
Electrical machines
We do not run so well
When not running clean
Bodies start to bloat
Off into death they float
When what we really need
Water for a seed
That grows into our knowing
That what we've put in
Matters more than we think
So change that beverage
And plug it in

Don't Feed the Animals

Animals eating good at the zoo
Locked in a cage looking at you
What we are thinking someone can tell
Zookeeper Bill knows us too well

He knows that we think like animals too
We eat what we're told inside of our zoo
The zoo that we're in has little control
The animals eat themselves into holes
Because animals eat what they are sold
Then animals feel tired and old

Though the animals eating good at the zoo
Never look tired until they are through
Living their lives inside of their minds
Naturally fed and naturally fine

So the animals sit there looking at us
Not in a cage but out of our minds
Living our lives always confined
To feeling like shit all of the time

Zookeeper Bill knows this is true
He keeps his animals separate from you
He knows if the animals eat what they're fed
All of the animals soon will be dead

Influence Needs Direction

Floating through in clouds so hot
Wish everyone on earth could see
What the clouds have done for me
They've opened doors into the mind
To clear away a little time
Of heavy years in heavy faces
Of harder times and weaker places
Floating through on a cloud of thought
Wish every person on earth could see
What imagination brought to life
With lighter times upon the mind
Now all there's time for is a trip
Into clouds upon a blip
A moment inside of longer time
About to leave an age behind
I'll step in to explore around
Try to find what can be found
Floating through in extra spaces
Into dimension is where the race is
Floating out on clouds a lot
Floating out on clouds
Let's all see inside the mind
Let's sit in clouds all the time

Wishing every mind could try
What it feels like not to die
Who it feels like always free
From who they tell me I should be

Does Anyone Else Remember

I'm old enough to know
Remember how it was
Adults standing in the kitchen
All night with a buzz
I recall people talking
About more than a show
I remember people saying
What you really need to know
Not just what it makes
To be the richest one
Not just what it takes
To fit the newest fun
People were much more
Than what they had on
People were much more
Than what entertainment's done

The Coolest Manikin

Dress them up to play a part
While thinking they are free
Have them express the newest fling
As far as they can see
Keep them thinking they're unique
By giving them a style

The older people have you trapped
By a mental mile

Dress them up in faster minds
That all may think alike
It takes no effort to scan over
What you think you like
Turn them all against each other
By grouping them apart

The older people have you conquered
As you think you're smart

That Conformity Stare

Those eyes meeting yours
That are staring you down
Put into place
Your permanent frown

As their minds are meeting yours
They are tearing you down
Putting you into place
Under their crown

Though they are not kings
For they have no power
They're just forcing their ways
Into miserable days

Don't you ever conform
For the day that you do
They will have stolen
That true part of you

Need You

From my point of view
The young look younger
Not that it's bad
It just leaves me with hunger
I can tell that I like you
From miles away
Though I hope you grow up
And all in a day
Not to be old
Not to be tired
Not for a job
Not into a liar
I hunger for you
To care about more
Than what's in a media
Than what's in a store
Than what's on a screen
When you can't see it means
That you're kept from control
Of the life you aren't leading

These Words

To define what they mean to you
Find what they mean to me
From this mind's eye is where to see

Once you've found what they mean to you
You'll have found what they meant to me
Then from my mind you will see

That there was no riddle for you
For all it really was to me
Words to you from where I see

The Overlying Truth

In one way or another
Every lie is a trap
In every way and infinite others
All truths are freedom
As in every day without exception
False is found to blind
And without a single doubt
Each and every misperception is bad

Truth in Music Saves Us

The people of music
Who just wouldn't be
Any more than you or me
They stand up there
In minds so bare
With all their care
Crafting words to declare
Search for truth
Inside your mind
Find only parts
That fit so fine
Punch the puzzle in
Take your brain for a spin

All This Time

The truth in art expresses to you
You do not see it go right past
Within that way of an open mind
Hidden behind entertainment time
It's fed to you from behind a hand
When you watch that movie or hear that band
Though you're too corporate and far away
With a hook in you though not to stay
For if art decides to let you drown
They only need to let you down
Though there is still a hope for you
To see the hidden as the new

As You Listen to Where You're Not

Songs sung at you not with you
Into you not through you
They're caught up somewhere inside
Waiting to fill your tide
Flowing somewhere you thought died
Those people on the other end
They're calling out to you
The people of the other end
Are trying to show you through
Entertainment time is done
The mind must open wide
To feel a piece of the sun
Break a light into your eye

A Gift to Music

If these words are found to sing
You can have the song
Though you must share them all
Then pass them all along
What I ask of each of you
Mean them in your heart
Search that place deep inside
That pulls you all to parts

You Complete Me

If you feel the need
To repay a deed
Then perpetuate light
Every time you feel
Dark stealing sight
Take your might
Turn your mind
Surrender dark to light
For the light in your eyes
Is our greatest prize

Help Me Not to Lose My Mind

I can't tell you who they are
You have got to look
They tried to warn you from afar
Though into lyric you never took
The time of sway is over
This all must come about
I cannot see it going on
Without a single shout
If it all blows over
Without a single sound
The edge I might jump over
In a single bound
To see you as an animal
Locked up in a cage
To pet you on the head
As you sit there in your rage

Knowledge of Leader

To the people of the future
Please learn from our mistakes
If we can't learn from them
You see we sealed our fate
When it was bad direction
It was really plain to see
That when faced into the dark
There is no light to lead
As foresights fade into deception
We lose our paths to life
Once happiness becomes a luxury
Then you see we've walked into
What someone else wants for you

The Shift of the Lift

There is that one reality
Kept shifted off the page
While we argue to the side
Which shifts us to a stage
Where we play a part of fools
With opinions caught in rage
Over roles so sifted off
There's not much left to gauge
As we speak out from the margin
While not knowing what to do
Not seeing that we've shifted off
From a place that holds the new
Where minds that read into reality
Can see that change is due
When minds are kept from knowing
Where it is they're living through

A Sight for Human

It's not out there to see
Unless you have the eyes
That search for the mystery
Behind the shaded lies
You into a painter's gallery
Of every skin you find
Martin Luther King and Hitler in a line
Of different tints with different hints
That it was art all this time
So down every jaded alley
Isn't down into the pine
Fear of death cakes a puss
That pours from racial crimes
Though we cannot be a gallery
With puss caked over eyes
When all we see are fearful lies
While our racial tension tries
To put our eyes out to the flies
Who sever all our ties
To see the different points in line
That show a different kind of mind
That could paint our world refined
Then finally let our love refine

Let's Open Type

Stereotype is the wrong kind of font
For a display of the real in front of a want
That world of the fitted, the what's in a face
To the depth of the skin of every race
Of minds buried and bitten beneath all that weight
Or a life spent in rags in a poverty state
And minds caught in riches avoiding arrogant fate
Though time and again it has been proven
Inside stereotypes a mind has been moving
Yet we still try to fit it into a place
Losing realistic at a close-minded pace

Did Money Buy Peace Not Release

How sad it is to see
Our race relations fall apart
Right at the dollar's seam
True colors break from the heart

How sad it is to see
Signs of racial tensions new
Has all that work for peace
Gone with money down the tube

Just how ugly are we now
Finding hate inside this squeeze
Will money break the progress
Of a love we all must seize

Oh how it hurts deep inside
To see those eyes hate my skin
Oh how it hurts to see
That money kept that hatred in

Our Misguided Value

Possessions are possessive of the body and mind
They're owning your lives not treating you kind
Abusing your children, stealing your spouse
Sucking the health out of your house

Where is the value found in this life
When each of you suffers under its knife
It cuts to your hearts then covers the stain
Though it isn't working for you can't sustain

The world that you know is falling apart
Though problems aren't there for you to outsmart
There's no way around what has been made
Humble yourselves to save what has stayed

When all your concern is for people you see
It is then you will know the value of free

Sorrowful Competition

Who can have the best possession
Without a thought for the abuse
With no time to live a life
With your neck in a noose
Now you've dropped and it's tight
Hanging there I see your stare
Your eyes asleep in this affair
As you ask with every day
Why do I feel this way

The Rungless Ladder

While you're looking up
They are looking down
While you try to emulate
They push you to the ground

Yet continually you try
To reach the richest look
Looking like you're trying
Biting on their hook

Though you were never born
With money in your mouth
You never sound quite right
So they spit you out

While trying to rise again
Good enough is missed
Then every time you try
You find they passed you by

So why do you go on, living in a lie

The Paper Addiction

Every day we shoot up cash
It goes straight to our head
Every time we shoot the green
We find a distant feeling's fled
For our addiction depreciates
As it is quick to run away
If it finds we're standing still
It will begin to fade today
Then why go chasing after
That disappointing in a deal
Why go to find a fix
That steals a life you could feel

The Heavy Levy of Any Addiction

Getting high swings just as low
When used to cover pain
We never can run fast enough
To outrun this stain
As it catches up every time
Dumps it out into our minds
As that pain we thought was gone
Is never further than what we're on
As the further in the more it fights
Though the more we fight we overcome
That unbalance addiction spun

A Life on Fast

Faster through a life
Always comes in last
Life is not lived
Always running past
Life's inside a moment's cast
Though you keep running fast
Straight into your future stash
That you'll be way too burnt to cash

Invitation Sent Into Darkness

This door is open to the worst of you
Come over toward the light
Repay your debt by giving in
To what you know is right
With no desire for a battle
I do not want to fight
All I want is to see you turn
From darkness toward the light

The Nero Minded

Has too much power found its way
Into the hands of very few
Has history not told this tale
Of what exactly not to do
Yet it seems we're here again
With those who rule showing signs
Of the madness in the past
Now creeping up into their minds
Must we rewind to find in time
Those men of power in the past
Must I tell you who they are
Can you not see, is it too far
Will history repeat to cause us not to act
Or can we learn from time, for the first time
To stop the madness before the fact

Love for Only Markets

Standing on top of mountains of money
Peering out from places of power
Looking down on streets from towers
Governments gone to your highest bidder
Puppets purchased who do your bidding
Choking the pieces that just aren't fitting
Fulfilling a vision of domestication
Which is your plan for every nation
To be the power over the people
To turn us into tools for making
All that money that you are taking
This search for numbers ever increasing
It costs much more than funny money
The people pay it in hopes and dreams
That you have stolen with your schemes
This capitalist systems evolving round
It seems to be lordship bound

Unlikely Mountaineers

One stands looking up from the foot of a mountain
Another is born upon peaks peering down
Worth is not told by financial well-being
When opportunities sold to one as they crown
This problem of prejudice doesn't stop here
As there are trails to the top kept from the rear
Though the top is sold as if one could climb
From the bottom to the top without that one dying
On top of all this there are eyes looking down
As if opportunity was not there once they came around
This ignorance baffles me beyond all belief
How could one think bad of a thief
When the view from the bottom is to slave or to starve
Without any real hope of a life without scars

Casualties of Capitalism

Those at the top are straining you
As most go down some get through
Though does it have to be this way
Must we suffer so they can play
Can they not see we're human too
Do they not hear our babies cry
Can they not feel a child's pry
When she sees her daddy cry
As Mommy's job says good-bye
They're cutting hours at the store
Daddy's checks don't come no more
Now they're out of baby food
What the fuck are they to do

Be Working Class

We are already at war
With the greediest of rich
They're winning the battle
While we're on their hitch
They pull us around
On games that they play
Then hope we don't wake
To see that they say
That it's all the teachers
That it's all the poor
It's those blue collars
That keep us on the floor
When it's all the bankers
When it's all the traders
When it's the politician
That refuses to leave
This system they love
In which they are staying
While we are so willing
To believe what they're playing
That it makes me sick
Let's start being heroes
And stop being dicks

Where Good People Went

Most go in good
Not knowing, unknowing
Of where they do go
Of where it all ends
Of where a mind bends
As it's forced to be cold
As care becomes cost
As fair becomes lost
As hearts become ice
Killing good inside nice
Though for what purpose
Putting people in cages
Feeding people to people
For profits in stages
Forcing the animal to gnaw off its heart
Removing its life from the living part
And now we look out to the streets
Only to find we have died
Now we walk out on the streets
To see faces buried in pride
Though I still see underneath
I still see you hiding inside
I know where we went wrong
And know what its inside
Today their profit has died

Society Is Meant For More

A society shaped by profit
It's what we have today
Their profit drives our problems
To the brink of our decay
A society filled with people
Who live to fit a page
Upon those balance sheets
Of our corporate cage
A society locked to profit
No matter what the price
We pay it with our lives
And still they want a slice
A society of more than profit
Is it such a bad idea
To turn a profit second
To the state of human minds
To turn a profit second
To a little family time
To turn a profit second
To poisoning the earth
To turn a profit second
For what it's really worth

Open Society

If we come together
Could we keep going
I'd love to see it
Where we might go
If we can make peace
All with each other
Can we please keep going
For as long as we know
There is a world I have seen
That if we could get to
It would be like living a dream
Right here next to you

Capitalism Flawed

Is it obvious by now
I think it should be
Our system is flawed
And it's easy to see
With our booms then our busts
On our bubbles of trouble
In that casino like Reno
But hey, what do we know
We're all just down here
Just watching you steer
As you're losing control
Of what you put in a hole
With the red that we're in
That you're pushing around
Corporate won't pay it
So who will be found
Well the rich have the money
Though they aren't so sunny
They would rather be tight
So they can watch us all fight
While they're fickle with trickle
Because of the pickle
Which was the price to expand
Far off past this land
That they no longer need
To turn profits to greed

The People Versus Corporate Monopoly

Every time we roll the dice
Smaller business pays the price
Feet at the edge of the board
Where bigger players set the rules
As smaller players count like fools
Trying to win without the power
In this game so bent and broken
Now they mean to take our token
For in their eyes we're in the way
Of their making more today
By choking people for a profit
To kill our hopes of doing business
Upon a board of leveled play
Where looping holes are everyone's
Or holes that loop cannot exist
For this unfairness cannot persist

Post Private in Your Windows

We own the true economy
They own the casino
While they no longer need us
To live their lavish life
Though if we were to stray
To finally disconnect today
We would have the chance to lead
An economy they cannot bleed
With small business standing too
Strong against their sector
Not investing public money new
But instead creating jobs
Of which we are in need
If they will not feed us
To ourselves we must feed

A Poor Agenda

The righteous motive spent
Minds over profits bent
A purest form of greed
Cannot be what we need
To govern all the people
From this place of power
That seems to only strangle
The chance for those
For whom they dangle
For they do not care to drop
The poorest people into place
Then sit on high upon tower top
As masters to the human race

Implementation of the Technological

As the inventive is bottled
Left caught up at a point
At which incentive to fuse
Our advancements of time
Are lost to a system
That refuses to shine
Where choking on profits
Is the price of our greed
While we pay it with time
That we lose to its speed
With ideas stacked in piles
Wasting off in a corner
Those advancements of time
Go straight to the coroner
While we search for an answer
That would turn things around
Not seeing those solutions
That we've already found

The Failed Experiment into Greed

Look where it's ending so deep in a jam
Loving the greed and wanting to stand
For lifestyles lived out of control
Loving just money while digging a hole
Deep into useful in no certain way
But buying that something you didn't today
It left you not thinking of anyone else
So into the buying of all of ourselves
Can't we by now say it's not working
To love only money as problems are lurking

A Government of Desire

A government's greatest commodity
Should always be its people
For a society of wealth
Is not measured by a currency
When a society is destitute
While in riches beyond their need
This measurement is misleading
As it has shown through time
For we have seen great nations fall
To this value unrefined

Their Currency of Power

This source of our current evil
Is turning people against people
To turn us in so we devour
Ourselves instead of them
Though into dark we must not turn
Becoming them we must not learn
But to neutralize we must go
By changing our directive flow
For dark must not into light enter
When new balance creates new center
We must not give them room to stand
So they may fall into light's hand
Then as the evil redefines
We step into brighter times

What a Line of Credit

It's time to wake from financed sleep
Raise your heads from your beds
You've been asleep on easy street
Living it up made you soft
You're waking up to falling off
Not from bed but in your head
You'll have to life to live instead
Though nothing's changed in this game
That was your play before today
So let's all value what we know
Not just what we know we own

Back to a Slave Ship

We all need a job
On a different ship
That one we were on
Had chains and a whip
Do we all really want
Back on that ship
When the life we were sailing
Had us all wailing
Those stripes on our backs
Should have us all thinking
Of abandoning our ships
For ships without whips

Inequality to What End

Equality is measured
Every single day
By how much inequality
We see that's in our way
Causing most of crime
With so much prison time
Which drives it that much deeper
Into this society we find
Is full of broken families
With parents gone away
To work the deck of ships
That have captains gone to play
Who make bets with the capital
While not caring for their slaves
And you must see it's true
Now you're to pay the debt
Of their bet you didn't lose

Class War Crimes

War crime convictions
Is it what we should do
To put down a dog
As crippled as you
You see only dark
You bite with your bark
How could you hate us
Or what did we do
Work in your factories
Go get your food
Type all day long
In small little cubes
Build all your houses
Build all your towers
Work all day long
For hours and hours
Just to be treated
With so much disdain
Before you had need
But now we're to blame
Just like the laborer
Just like the teacher
Just like a tool
You have no need for

Not like a human
Not like a friend
Just like a person
Who did not pretend
Who knew you are the people
Who made all the dough
And we are the people
Who made it all flow

They Mean You

If we don't come together
This is the end
We will never be here
Ever again
Where we can see
Where we are going
Can't you all see
That our country is going
Into the nut house
Of the criminally insane
They can now kill us
Without calling our name

Road Work

As Wall and Main run parallel
They're disconnected by the swell
Of those suits that know our face
Though will not hear a change of pace

Who needs walls we don't climb
Who needs them when they're dying
They're so sick they rarely see
A life is lived from you and me

So disconnection's what they want
Let's disconnect with their front
To make a street all our own
Keeping new ideas for us alone

We must starve them of our minds
For our ideas must never find
The road to streets that disconnect
All of human intellect

Separate From Infection

When corporate fell into the dark
Humanity followed it in
We by now should see this
From where we must begin
It crumbles now under its greed
Stealing every life it bleeds
Into a bucket of your blood
Where we must see we're at its end
For who awake will want to go
To search for sickness darkness grows

Our Spread of the Corporate Disease

I'm sorry, China
I'm sorry, India
I am sorry, world
I'm sorry for what it grew
I think we see it now
It doesn't care for people
It doesn't care for me
It doesn't care for you
It can't and it will never
It isn't made of truth
We couldn't say I'm sorry
Enough to see it through
Though I'm sorry and I'm sorry
I'm sorry so, so sorry
I'm sorry that I have a sorry
That I could never get into

I'm Holding This Up to Your Mirror

You are kept in this state
To maximize profit
Your mind is theirs to turn
They do it as they please
Tell me when will you learn
That the best of your interest
Is not inside their mind
It is in your own
And it was all this time

The Newest Religion

This newest faith has no God
In temples of glass and steel
Erected into the sky above
This faith cares not of any love
It rules our lands from on high
It trains to open an evil eye
Will its believers do its will
To make this species dead inside
So they can work from nine to five
Then go to meetings until they've died
I hope they see before we crack
That they will kill us at conversion
They may wake inside a day
Of suicides with no coercion

The Union of Opposite Action

One has their prophets
The other has their profits
One believes in families
The other breaks them up
One cares to love
The other cares for none
One of them must see
The other won't be done
Until they both become one

No

We probably have to fall
To learn what we should know
We probably have to ball
For our sanity to show
Though I've hoped I'm wrong
And we can learn the light
For the path that we are on
Heads toward our darkest night
Where times of pain and sorrow
Do coldly bite us every day
Where business takes the minds of all
As the humanity in humans falls
Can you see where we're headed
So deep inside this kind of mind
Can you not see a future full
Of those who bite each other's time
As we sit there locked in cages
Where corporations keep the blind

Please Think, Older People

Now that you're elderly
They do not care
You can go starve
With government flair

They say that they love you
Though you're just a vote
They lie to your face
While hoping you float

Far off into death
Before you can see
That all of your money
Has gone to the sea

Deep into the pockets
Of most of the rich
Who put all your family
Straight into a ditch

Amend Our False Times

You have to breathe
To be alive
You have to feel
To see alive
You have to know
To hear alive
That is why
They're dead inside
Corporations do not survive
It does not feel
It is why it steals
The lives of those alive and real
To find the meat for a mind
It does not have and will not find
Inside of all that stealing and lying
That makes the people kill while crying
Though this is how you know you live
You feel remorse and a love to give

The Citizen Without a Heart

The corporation as citizen
Sharing each and every right
Flowing freely as they speak
Cheating us as they sneak
Through their channels declaring war
Or speaking from a government floor
While holding for ransom each of us
While throwing us under the bus
Does this not seem an act of war
Attacking the people without reason
Can we not seize them for this treason
Then sell them off to pay a debt
Of all that money we did not get
If we are truly for the people
Then by the people we should act
To take what's left of governance back

Sever the Sector

They're so clever with their lever
They pull it down to slide around
From a sector to a mound
Of cash they stash from public ground
As this conflicts all our interest
Their interest is not public service
But that interest that they gain
Sending contracts to future fame
That they reach once they're game
To slide from public to private sectors
Where once inside those dividends slide
Into their pockets they don't care to hide

A War Hidden Away

This war's bloody carnage echoes through the past
As deep into distance as the eyes cast
This searching for times of days without war
Has brought me to tiredly sit on the floor
For into the distance that money I spy
Clips wings of thought necessary to fly
Away from the trappings of traps which are set
To catch the poor mind into a net
Which limits the knowledge with what it will let
By setting a boundary that all of us get
If thought crosses over it shames you for seeing
What really happens to naive human beings
From the time they are born to the time that they die
They're kept in the dark with propaganda and lies
If we're not at war then why use these guns
Let's put down the arms to walk in the sun
To talk and to think of what's really needed
To conclude this class war without one defeated

Citizens' Disapproval

You took away our power
When you took our mind
You were not the first
To profit from this crime
Though you still continue
To do it one last time
Your crime against humanity
Making profits of calamity
While lost inside insanity
The citizen is kept blind
Deep within your vanity
Of the greedy mind
This doesn't work for us
As it works for you
You're the one that's broken
Now we see right through
You really should step down
From your place of power
For all the pain you brought
Now should be the hour

Come On

Politics slid onto media
Say can you see
They made such a switch
Don't say you can't see
You saw integration
Please tell me you did
Unless I'm alone
And behind your eyes
It had slid
They do not respect you
When you're given a show
Can you see what that says
About what you must know
With such long ways around
Just to give you a lie
Can you see all that effort
To ensure you don't spy
What it is that they're doing
Behind those closed doors
As they're laughing at you
Those fed by an act
As they do what they want
In front of your back

Governed by Purchases

Are we governed by what we buy
Is every purchase a vote gone by
Do we purchase our own demise
When we vote for super size
But what about the ma and pa
They could have what you want
If what you wanted was a street
Of your own they cannot defeat
Public or private is our only choice
Vote for walls or in the voice
Of all of those on our street
Mainly missed and mainly beat

Cocktails on the White House Door

We should throw it in your face
Though we don't stoop that low
You cheated on us in our face
With the corporate hoe

Did you prefer a private place
To our open public space
Did you prefer shiny suits
To our old and worn-out boots

Does it love you just as much
Did your heart we ever touch
How much love was not enough
How much trust did it cost for lust

And why should we love you so
And how is it that we could know
That you no longer love that whore
And it no longer wears the pants
In your money-fueled romance

Accountable to Country

Within any other servanthood
The consequence plays a role
In how a person understands
Lies committed can bind the hands
In all but one this is true
Our public servants can get away
With almost anything today
Though why is this when they hold
So many lives inside the fold
Of every action that they take
After every speech in which they fake
Who of them will speak for change
Only those that are free of guilt
Would take away their easy out
Then stand their ground and for justice shout

A Message from the People of the Former United States of America

You've become an evil twin hiding in our sight
You've become our biggest spin, our unwilling fight
When we peer into your past
We see a valiant youth
You were headed down a path
Of innocence and truth
Now it seems you've given up
You've let yourself become
Conjoined to an evil twin
As he your head has spun
Now you're walking down a path
Of profiting at any cost
For your evil twin became nothing but your boss
The United States of Corporations
Is the name that I bestow
No longer fitting is the name
Of the country that you sold
We the people present here
See you as you are
You do not belong to us
We don't feel you anymore

Building on Franklin

Power cannot be held
Without eventual corruption
No one system should hold it
So long that it be corrupted
Once corruption has taken place
That power must be let to die
So the powerless may start to build
A better balance from the ground
While learning from foundations
By which the old had fallen down

Perpetual Democracy

A council shaded with every color
This power tiered by every age
While split by gender at every stage
Let this be our representation
A vision of equality here never seen
Into a future where hopes are clean
If we wipe away this dirty slate
To leave behind pointless debate
Start to talk of necessary change
To link a profit to progression
Not just progress of the selection
Though not mere progress of a profit
But prolific progress of the people
Tying the poorest onto the heights
Tying the heights onto the poor
Putting to work the best of minds
Into the challenge of our time

The Manufactured

I watched you go in
As I stopped going through
When you went in the dark
You dragged me in too
As they created a person
That no one should be
A close-minded mess
That's stuck in a place
Where no one can see
Let's call it America
Let's open our eyes
To see the direction
We took with their lies

Muzzled Pets

A petting zoo is what we are
They pet us with a phone and car
To keep us happy in a cage
To keep us from our primal rage
They tell you that we fight to free
Though freeing arms is all they see
As long as it's democracy
As long as it's not corporate greed
That keeps us freeing all the world
From the richness of their lands
Without extending them a hand
Then in the petting zoo we see
What they tell us on TV

The People of War

A nation of warmongers
Bloodthirsty for death
So very thirsty
Wars on their breath

One thousand years from now
When we look back to plea
Who are those that we implore
To change the world they see

A people of war
The people we are

Is that who we are
A people of death
With war on our breath

Give Peace a Choice

What is a chance
Is it a lot
To give peace a chance
Is it romance

If we had a choice
If we had a voice
If there were a vote
In war would we gloat

How many deaths
Until we regress
Until draft has shown
War's what we've sown

Does dominance come back
As towers turned black
If peace had a chance
Would war we romance

Your Generous War Contributions

Who pays for war
Who gets the prize
Is it all hidden
From each of our eyes
Let's swallow the trail
To tell who gets stuck
With all of the money
Then all of the muck
Who pays for war
Some pay with lives
Some pay with taxes
Some pay with sighs
Some pay a visit
To pick up a check
That each of us pay
Though what do we get
Well, we get to die
We get to cry
We get their lies
While they get the prize
While we have no choice
But to throw out our voice
To let them all know
We see what they're doing

They're making their money
Straight out of our pockets
They fake the reasons
We buy the rockets

Revolution Day

Let me say what's on your mind
You talk about it all the time
You say if it remains this way
We need a revolution day
I once replied to what for who
When no one cares about the glue
We're governed by our corporations
We are a people without a nation
To play that balance in the act
Between the power and the people
We've lost our governance to the money
Now we seem to think it's funny
It was then you said, I've known that too
I then replied you're sniffing glue
This country cares for only money
When the corporations say it's sunny
They close their eyes and put on shades
To walk the streets of darker days
Just look at all their misery
They still want more of chase the dream
They're locked away inside a scream
A revolution, ha, funny
Not with people who love only money
For the pain of others I've watched them sneer

They cannot feel another's tear
Only self is what remains
The only way we'll break it down
Is if the good came around
You shook my hand then walked away
To spread your revolution day

You Are Revolutionary

You are a number
You are just one
Though united together
An army has sprung
Minds marching on capitals
Of metal and glass
To tear down their world
For freedom at last
What you do with this freedom
It is all up to you
You can build true democracy
Or build something new
Though whatever is built
We must stay together
For in this lies our hope
In which freedom is tethered

A Little of What You Already Know

Who to trust
People who tell the lie
People who tell you truth
Have we known it for a while
Who it is that's killing you
I won't tell you who
You look out to see
I won't tell you who
I don't have to, hee
So I'm standing here with you
I've raised my hand, I'm in
I'll go on to hit the wall
To push it down until its fall
Onto the ground until it's found
To be the dust lying around

Cinder Lust

When afraid and fierce collide
Pieces fly out from a side
Away from fierce into fear
Fierce blows back fear so we can hear
Then all those fearful things we're told
Start to sound a little old
Without the fear inside of fierce
Human minds begin to pierce
All those lies that they are told
That break them down to keep them sold
On that fear that hinders us
Though fierce creates a cinder lust
For burning all unbalance down
To build a balance from the ground

Proud Over Pride

Can you imagine a society proud
Standing against the pride
Where people rose to save themselves
From systems that have died
Where once together they all grew
Into those people who all knew
They saved humanity from the pride
By letting go to turn the tide
Not wanting what they had before
They moved to pass then close the door
On older time that they were through
While looking back on what they knew
To speak from hearts proud to say
They were those who stood their ground
To finally turn the world around

Tell Our Future

Your direction is the future
You go to get it now
You write it where you stand
You walk to where it lands
Take this pen from my hand
Let's step out all together
Let's walk until we see it change
To ensure these days fade to strange

Under the Banner of Change

I am me
You are you
We see one world
From different view
We don't agree
On what we see
Because we came
From different days
So spread apart
Into a maze
Where into boxes
Of different mind
We're set apart
By different time
Though if you read
Into my view
You'd see the common
Need for new
When all want change
To come our way
Through our difference
Eyes must look
To see the change
We seek to hook

On
December 21, 2012
White Shirt
The Word "Change"
On the Front

There is a way out
We just aren't trying
We're not trying to see
There is a way out
Though we all must decide
To stand up together
In every city
In every town
In every district
On every mound
To say we want change
If we really do
We will stand up together
From our TVs
We will stand up together
Out of our sides
We will stand up together
As those who want change
We will stand up together
To turn the tide

Worth More Than a Million

We'll have a million reasons
Why it was worth it
Why it felt right
Why we'd do it again
All over tonight
So let's go out
Let's step right in
Let's change the wind
To turn the tide
To pull those lies
Out of our eyes
To find the truth
Was all we need
To wash away where we bleed

Last Year

I knew enough to know
To know not where I was
Though I had no idea
That this was where it was
As I lay halfway out
When I woke from sleep
As I thought I knew
I was breathing deep
Though when I woke I knew
That I knew what blew
So I wrote this word
That I hope you've heard
Deep down enough inside
That you know I haven't lied
So if it comes to get me
It was for you I died
So hello or good-bye
For this year we'll have to wait
As I hope we have a date

Beyond a Build-Up of Time

As we live through the decades
That have already been
We're in search of a light
That has gone with the wind
For the remnants of light
Are all that remain
We look through the past
Though only in vain
Times have moved on
They're now covered with stains
Someone wrote them over
With a false sense of frame
Though those who look through
To the purest of true
Can see the time turning
From the old into you

Grunge-Filled Flower Power

As love and anger merge
We're all upon the verge
Of the newest road to take
Into the true from the fake
Feeling out those new directions
Which we all will go
Searching for the newest mysteries
Of whatever world will show
As everything parts again
In all those different ways
Split into different meanings into different days
We will see that all of us
Are all a different part
That put together into one
Has made the newest start

The Other Side to Light

If you look into my life
You could find hypocrisy
Though if you'd look into the mirror
You could find the same
As we're searching for an answer
With all of us to blame
While looking for the perfect
That we do never find
But only in a story
But only in our mind
Let go of the unreal
To see our knowledge kneel
By those mistakes we feel
Are the ones we must change
To see those days fade to strange

Stories

They are something that can't be true
They're something that can't be proved
A something that should be true
If lives are lived by them too
Why not question why we're told
You have to pick a faith in bold
It seems to me that stories trap
Too many minds that won't come back
From all the truth the stories lack

A Convert's Love Story

Hope again had found my face
Look at me, your old embrace
Remember when you found your love
Reflected in that God above

Never had I broke from bed
To see the love that never fled
Now faith and fear are in my way
To showing you what I must say

That love had never really been
Inside a God without a sin
So every word of love we've spoken
In every time we found them broken

Our every act we command
Without a God to guide our hand
In this truth there lives a hope
That if all the world could see

We can find a reason
To finally be humanity

What Faith Does

When all you need to think to do
Is believe your way away from blue
How does this affect the mind
When to think is its design
It seems that faith steals a chance
To live a life while being free
To let your brain begin to feel
A life where you're awake and real
With every turn you'd be at it
Thinking about the path you're taking
Living life while never faking
Letting yourself decide direction
While knowing love lights affection

Rusty Bread

What is old
Was once believed
As what is believed
Will soon be old
Look at religion
It is sold
For they know
It has mold
Hence the need
For lots
And lots
And lots of gold

Religion Was Art

The artists rendered reasons
To connect us to the stars
For whatever reason
Be it freedom, be it bars
Or be it an expression
Of the creative mind
That over time was twisted
To fit what we now find
Eyes locked away in stories
Meant for an ancient day
Minds missing hidden meanings
That went their ancient way

What Wouldn't Joseph Smith Do

Relentless spread of the misled
Two on bikes with devil's speed
Spreading poison all around
From door to door and town to town
Unless you're racist you're mortified
To hear what people of color say
As slaves for others on that day
As they step into their iron gates
To show for heaven as masters say
Welcome to the Mormon bars
That locks the race into the stars

Judge, How?

If you were God there'd be no guess
You'd look to see a year from now
Not one surprise with no wows
A child born you'd look to see
The genes he'd get from family
You'd feel the wind on all your toes
You'd know the weather as it blows
You'd see the wind on child's face
You'd see it mold its inner space
You'd know a household and a hall
It would take no effort to know them all
To see a city, to see a state
To see a country on your plate
Then on your table the whole world's fate
You'd feel the heat of every breath
Beating down upon the neck
Of all the children born today
That you just sent out to play

Do We Feel Like Idiots

Genocide, yes genocide
Not just circumcise
I said genocide
So who is God
When he says
All your land
Is theirs instead
As he gives right
To kill them all
All the way
To a child's skull
Then we teach
Sunday school
What the hell
Ring our bell
Wake us up
From this spell

Eat the Apple of Knowledge

What a thing to say
To scare a mind away
From the one and only word
That they know but haven't heard
All locked up inside a theme
That keeps the brain inside a dream
Of demons, devils, and God supreme
Who never seems to be quite there
He eats the apple on his mare
As he rides her out of town
He's sold his rotten apple mound

If All Things Are Possible

Supposedly there is a God who can do it all
He could decide to fix the world
Make all the evil fall
Instead he wants to punish you
Inside a crooked game
You're set up to feel down
It keeps you needing him around
It is also said that he
Does not need a thing
Yet every week he wants your cash
Even if you have no stash
So why is it we do not see
That this was just a scam
Is it that fear of eternal fire
A loving God took time to fan

Dislike Without Reason

It's ten percent to join
It's every single month
You are buying a community
Where you can have unity
I'm not minding that
When it's not that bad a thing
It's what you do to those of us
Who can't get on religion's bus
For science drove on through it
I just cannot come to it
Though if you were lost and walking
I'd stop to pick you up
With no reason to dislike you
Though you're told to distrust me
Can't you see why I must
Be sure religion sees its dust

Let's Move On

A God is a miscalculation
Of the newly self-aware
An elusive search for self
From behind a primitive stare

This is why the omnipotent
Does rarely agree with us
We outgrew an older mind
While God is left in our dust

How far into future thought
Will the past come in to say
Killing children and genocide
Are actions we should play

If this God does never change
Then these ideas will remain
I'm not sure just where you stand
Though I can't stand in the insane

The Love of Bastards

If he was real
He was not born of a virgin
Being a bastard not treated so kind
The people around him all were too blind
As his word was not heard
For it offended their pride
Some bastard nobody
Was turning their tide
While caring for light until he had died
Hoping they'd see the love in his stride

Love in Balance

Don't love to your own end
Unless you see it matter
Once love has found a limit
You know that you are in it
By the pressure of the anger
Building up inside of you
That must release to balance
A love you thought you knew
For to walk into the light
Without ever looking to
The dark side of the earth
From the dark side of the moon
You burn into that love
For you are of two sides
To remain inside the day
Is to collect the darker tides
Though do not turn from light
When your righteous anger builds
A brighter side to love
As the negative always yields

Your End Times as My Star Aligns

So it seems you lost your love
And that the road was wide
You ran down it in a glove
That you put on your mind
You told yourself you're squeaky clean
Your puppet glove took that scene
It wasn't you who took the role
Of the arrogant lukewarm soul
As the masses chase it down
Wanting the role of this clown
Who's running straight into a wall
That's way too big and way too tall
A wall of fire without a ring
A wall the size of everything
That no one's able to get around
A wall of light the earth has found

Last Call or Fall

Take these thoughts then look around
Everywhere they can be found
Look for signs of insisting change
The world is soon to rearrange
Some of you may see it coming
Some of you may know it's true
Each of us has need to ready
To leave behind a world we knew
For time has opened to redefine
Just in time to leave decline
For all know down deep inside
The path we're on ends at pride
As pride will never turn a tide
For of pride new cannot reside
And this is why pride will burn
So that humanity may learn

False History Unraveling

Those ideas of old
That we keep flying bold
Have found a place of dying
At the end of our lying
Like novelties they are flying
To the moon of our landing
Where in dimensions we'll be standing
If looking back we are handing
The last of old to the sanding
To find a place for our banding
A change the age is demanding

Naked

So here I am
You can look into me
Read into this mirror
Faced into the sun
It's reflecting to you
The truth I unspun
So trust what I've made
Though do not trust me
Unless in it I've stayed
This light that you see
Don't look to me
Inside of your mind
Trust only in truth
Of whatever you find
For all that I did
Was look into new
To find a love hidden
Inside of you

Where Darkness Stands

We have left too much room
In the lack of our action
To do what is right
Without so many retractions
As we fail to express
The fullness of balance
The essence of failure
Is to watch the intended
Not emerge from intention

The Dissipating of Love

The system is set
A people in place
The shaping of human
Right into the race

Though what is the future
Of a species defined
By how well it does
At cheating its kind

Where will this go
As genes travel on
Which ones will breed
Which ones are gone

How long could we last
Once it's turned in our head
A love in our heart
Into cash there instead

Unnatural Natural Selection

We're not used to responding real
Though if we'd only peel our spiel
Then we would feel that real
Then see the place that steals
It takes away where we meet
A place we need to work it out
To finally see what it's about
Why the truth we all must shout
To ourselves about the fake
That put the distance far between
You and being awake

Bonobos in a Land of Chimpanzees

Looking out into a species
Searching for just where we fit
While finding most monkeys hit
Chimpanzees who want the thrill
Of oppressing others from atop a hill
Pounding chest while knowing nothing
Of what it feels like to be loving
Or how it feels to look for eyes
Expressing love of closer ties
In this connection lies our lives
We are still in breath but not for long
When chimpanzees oppress the being
Of those who have a loving feeling

I'm a Loser

Because I cannot help but cry
Because I still care
Because I won't conform
Because I still believe in love
Because I'm not wealthy
Because I don't wear the right clothes
Because I don't say the right things
Because I notice a tree
Because I hold a door
Because I don't have to win
Because I'd rather hide
Because I want our world to change
Because I can no longer watch us die

Pretty Primitive

To think we are advanced
Is not to think at all
Once you're done learning
Out of the sky
Anything could fall
Pride is never learning
For it already knows
Though when you never look
Don't you be surprised
When you see it show
And yeah, I know

The Race We May Be Losing

In the search for a future
A primate takes the place
Of a people well advanced
When only peering into the past
For inside the search to forward
I have found I'm needing you
To grow up past that view
That you know just isn't true
For we must learn that time
Is moving past our mind
At a rate so much faster
Than this society's decline

The Value in Our Design

The people of the surface
Are always looking to
The face of what they see
But never looking through
Stuck inside the physical
Stuck into possess
Stuck inside a game
Meant for a different test
While one meant for a brain
To be its very best
Is the weight of human thought
A test we must possess
It builds the reason for
Our terrible design
Our best part is the brain
You should work your mind

The Preferred Human State of Aware

The very function of a mind
Is to become aware
Awareness is the sight
You always felt was there
That very thing you fight
The thought you're scared to be
That one you know is true
Leads your eyes to see
Though only if you leap
To go from where you know
To a different place of mind
Where expansion knows to grow

The Most Valuable Design

The human brain is squandered
Under these mind controls
While locked away to wander
The useless place it strolls
Kept tightly in a corner
Of simple prison cells
Making choices from a list
That the corporations sell
For so long it has been like this
Who we are I cannot tell

The Regressive Elimination of Imagination

So deep inside of memorization
It's hard to find imagination
Trivial cataloging can jeopardize
Brains it fills not exercised
Get used up on memorization
That stifles abilities for creation
Of mostly necessary information
Especially in times just like these
As humanity drops to its knees

For the Necessity of Truth

The ability to imagine is more
Than the ability to know a fact

Though correct knowledge is necessary
For precise imagination

Ourselves to Follow

Where we imagine we go
What is said it will flow
How we think it will grow
Into our own futures
That we ourselves make
Let's plot out a course
To make a new wake
From the steps of our cities
Into the distance of space
From those minds locked away
Into a freedom in place
From the need of pollutant
Into a perpetual energy race
Let's make those decisions
That are hard to replace

Reach With Me to Better Ends

There feels to be perpetual energy
Between the gravity and light
I cannot quite yet see it
Though I feel that I might
I will keep to reaching
So that we may have peace
So we may argue battles
Over the brain's brighter release

Create or Destroy

You will and do forever choose

What Goes In Does Come Out

Black is not within our hearts
It is within our eyes
As light comes through the black
Within full spectrum pupils lie
As all the color flows into
The darker minds go in too
With ideas that monkeys see
That certainly those monkeys do
Though if we were to perpetuate
It would not be toward the dark
For the dark it does not grow
The love that fills our hearts

Close the Back Door to Light

To come in through the back
To lay fire under feet
It just won't ever work
It has always missed a beat
If you stand for fueling flames
To create a brighter light
They will also learn to gain
Any lie you thought was right
The light must be out front
With any truth you can find
For then a mind could touch
What it is you stand behind
So turn your mind into the sun
To leave behind the darker spin
For it turns you into the moon
To shine a light reflected thin

Everything Lending

Nothing ends as everything's ending
All is bent as everything's bending
Nothing mends as light is sending
Though all that is, is never ending
While all that is, is ever ending
Our loop is closed within a sphere
Air so clean was not so clear
Trees so tall at times were small
Small at times came from a steer
Now finally the time is near
That one could say a time has come
For feelings flying from a gun
To strike our ways to send them down
So minds may rot to feed the ground
For all the hateful things we do
Will only grow away
With a different point of view
Every single day

Pollution of the Nearsighted

As long as hands are mostly clean
As long as eyes don't come to glean
That dirty world that we leave
To those masses that we make
Through a love we mostly fake
Have we lost our sight for love
Is caring now not good enough
To save ourselves from being the ones
Who insert a sickness into the lungs
Of future children who sit to cry
As blood and tears pour from their eyes
They are our children that look back to us
To wonder why they did not care
About a human without hair

I Had to Let This Out
If I Kept This In
You Wouldn't Know the Full Extent of My
Anger
I Gave You Everything
So Sit, Stay, Play Dead, or Stand

Humanity can go backwards
You're seeing it happen
Will we sit and do nothing
Then look down at the kids
And say, I'm a coward
Look down at them now
And say, I'm a coward
Lock them in cages
Right fucking now
And say, I'm a coward
And take your fucking bow

We Are Fools

Nations full of families
All of one kind
As variety of monkey
Though if looking into time
An ancestor was brother
Born of the same mother
Walked their different ways
Into their different lands
To only lose connection
Then turn and rape their sisters
Then turn to kill the fathers
Of those who parted ways
While knowing love of distant days

Pure Expansion

Let those truest ideas win
We need not kill over them
Let time judge them all
Let those false take the fall
Empty outward what you know
Find those thoughts that didn't grow
Let it be what you knew
That did not grow into true
Then arrange that mind every day
From a place no one should stay
As stagnation of the old
Can choke a mind's expanded size
That cannot see from older eyes
Into where age is never wisdom
Unless it saw through the lies
Which wisdom will forever know
Are sometimes light that didn't grow

I Have No Enemy

This book is not a threat
Though if you find it is
It's where you cannot see
For if you knew my point of view
You would know that this is true
For I desire no one's hurt
If this you cannot see
I'm afraid I bear bad news
I am afraid you cannot see
We should not see anyone
As our enemy

Murder Hurts Us All

As darkness stamps out light
Forcing truth into the ground
It takes our species' future
Then rounds it further down
For as it kills our hope
It has darkened every eye
For if light is left to live
A brighter world it would give

The Consumerist

A people defined by what they own
Do never need be great
They never need be nothing more
Than what is purchased at a store
As years go by the decades fly
Their minds need not ever try
To find expansion past the state
Of what to buy on a future date
They forget the world around them breathes
They forget those lives need to feed
They lose a reality of the place
Where the rest of us live at the base
They forget the base is even there
They lose the sight of their glare
They forget the stewardship they had
For consuming luxury drove them mad

Please Save Yourselves
And Um, I'm For the People

What if they get rid of you
What if you can't stay
What if your darkness wins
And it's millions against you
All in one day
What if light doesn't win
What if they all turn dark
What if they decide you're the enemy
As they step out of your mental cage
Needing to express their buried rage

Steps of Inevitability

There are those of you
Who want the rich to bleed
Will you give light a chance
To not into darkness feed
It is better for pride to burn
Than it is for people too
Let us stand together first
To ensure their ears are hearing you
Before you go to collecting blood
Please let every structure burn
Before you spill the blood of others
Let us see if we can learn
For a peaceful resolution
Is a healing we must earn

What You Do Beyond Chance
Is All That Matters

Our different genes
Through different light
At different times
We were born
Into un-equals
Of different experience

Genetic Driver

What else but a thought
Would drive a gene
To change its course
To want the means
To improve a life
For its own survival
Upon the earth, upon arrival

26,000 and the last 100

A coincidence of the extremely strange
For our recent rate of change
To land upon us in this time
As stars align to turn the age
With fire lights as father cycles
Affecting all there is to see
With the earth as the mother
Giving birth to you and me
All this time were we too blind
To see a star as Darwin's key

A Finite Number of Infinite Ideas

Limits there are in all we do
If we don't come to knowledge new
To start the building of something true
As we are headed toward a wall
That just may be way too tall
For our species to find a climb
From that low of a decline
As there are no guarantees
When spiraling out of control
That we will not fall
Into too deep a hole
As we are not infinite
We are not time
For we are a cycle
And you are a mind
Of body parts materialized
Of which one day there's none
As the earth will someday
Be drawn into the sun

Information Channel

If our channel was tuned
Onto the right frequency
Can you imagine the advance
That humanity could see
For with so much distrust
Among so many people
Our minds never share
Those ideas that can grow
Into the new renaissance
That freedom would show
For power is wasteful
When minds cannot know
The expanse of our eyes
Of a channel that's tuned
By the removing of lies

Jupiter Swallowed My Pride

Jupiter took my pride
If this all comes to pass
For the day that I was born
Is a day I did not choose

A Symphony of Starlight

You're like seeing naked starlight
As to write this felt the same
You must know who you are
This was no orchestrated game
The details much too close
To be anything but music
Notes written on a sheet
While starlight plays on beat
Without time to read a note
With no time to draw the line
Light conducts us as a symphony
Of those in starlight minds
As this must be the hope
To lay conduction on the sky
For a humanity harmonized
Would make everybody cry
For to see its beauty play
Would be worth a life to try

The Brightest Secret

There is something hidden
In the star of the day
There is a certain light
While the earth turns away
As the sphere is going down
Stare into the round
To feel something sound
As that something enters
A feeling finds an out
What it is I cannot say
Though I feel it live today
Seemingly it helps me
By putting light to paths
That slide my feet to feeling
Steps meant to last

Looking Into Love

I have finally found it
I now know what it is
We stand attached to earth
Peering out into the sun
With our naked eyes
Seeing the source of love
Without this burning light
We are nothing now
Without this given life
Our time would take its bow
As we will grow with it
Or we will find our end
As this light gives us life
It also burns the dark within

Horizon Time

Let's look into the sun
Evolve toward the light
Let's look into our star
To find what we might
When low on the horizon
As colors come to play
Let's look into the sun
To find a brighter way
Let's look unto the earth
That we may not forget
That this light we see
Will always find a set

A Reproductive Pattern

From the sperm of the sun
Into the womb of the earth
Every year she's given birth
As is the light of man
So is the gravity of woman
With a conception then birth
Of a sun or an earth
From the penis shines light
Into the pull of vagina
The cycles continue to breed
Into forever patterns will seed

Beyond Begin

Begin is limited to a place
Seemingly fit between a space
All we see can't start at one
Begin flips into the sun
There was forever there'll always be
Forever have cycles spun to free
As a cycle starts while cycles run
Though a cycle finished is never one
It's just a flip of two just like you

Light

Look to what drives us
Look out into space
Like wheels they are churning
Creating our pace
As light falls on to us
Creating our eyes
We look back into it
To find all our ties
As the patterns are falling
To fill up our place
We look for its answer
Forever to trace

An Eternity of Infinity Mirrored

All you see
Reflects itself
In different ways
With different kinds
In different sizes
All the time

MUUNITNOCONTINUUM

Must math be done with answers found
Figure eight seems to be
A broken line when conceived
With death too near to see too far
What of the point of view of star
Could things not be the way we see
Could things just be without a key
When did time begin to trace
The lines and curves of any face
Existence seems the proof of time
Existing as a single line
It seems the void of all that is
EMITSTIME

Everything Fractal

Every single thing I see
Echoes out a mirrored fee
A price it owes to exist
Is to link with what had kissed
At that time our cycle started
With an image we had parted
It's not a copy that we see
Just a pattern imposed is free
To express this story hidden
Which tells the truth about our being
Linked to everything we're seeing

Truthful Minds of Starlight

Just a little bit of truth
Is always shining through
Everything we see or hear
In most of what is new
A picture fills into place
When minds filter through
Most of what we knew
That doesn't follow through
Into the newest cycles
Of those creative minds
Who bounce along like balls
Onto the walls of their minds
As they're trying to find a middle
To shine it off your mind
To help you solve the riddle
That keeps you in a bind

Stellar Programming

A multitude in constant motion
Churning life as they shine
As the moon turns the ocean
A starry light writes our mind
They pull us here then leave us there
To show us where the eye should stare
All this time in search of how
It was the light that took a bow
We travel on with mirrored notions
As stars put forth their perfect potions
The shining forth of new directions
To start a climb away from dying
By a putting forth of brighter signs

Light Beam Clockwork

Those with knowledge of the stars
Are those who know us all
Knowing when our eyes will open
Knowing when they may fall
All that passes through our sky
Mirrors down through the earth
All that happens to our mind
Starts from lights lined up burst
One can gain control with knowledge
Or one can set you free to be
Open to the light that's falling
Or blind to why we need to see

To the Unborn Cycle

The next time we wake
It will be to destroy
If we fall back to sleep
We will wake to deploy
As an army of ants
Each with its own mind
That is set to take down
The pain that we find
For to watch it go on
Will be but to die
To destroy what we see
Will be to open our eye
This trust I must tell
From where I do see
If we don't come to light
Our end it may be

The Progression Through Time in Starlight

Time aligned as hourglass
The sand we are to it
When time gets old enough to end
The newest time is in the flip
Though sand shifts around a bit
As the sand turns in to sit
Then time begins to redefine
In different angles of the mind
Only to build the other end
Then need to flip and turn again

From the Plane of Awareness

Reflections through planes of water
Is where we all exist
Through each plane there is a change
Of size your eyes don't fit
Though if imaginations freed
The echo of our eyes will see
That all there is to be
Mirrors through then moves to free

Into Death Looking Onward

I know nothing of an afterlife
Though I do know this
That learning from the light
Is to become its kiss
As light is always moving
To expand through the unknown
While we know not of after death
Except what the light has shown
To expand with the light
Is to send it on forever
For within dark's frigid bite
An end there is to expanding sight

The Pull of Propulsion

Is the black hole pulling
As a tail of a light
That we cannot see
Jumps from our sight
Into further dimensions
Of which we do not know
Though I bet there's balance
To all of its flow
As light pulls to center
Our light that gives life
Will give in to the hole
Traveling into its time
To continue a path of ever refine
As we pull away from where it does go
To flow with a light dimension must grow

The Underlying Truth

The dark is only light
That we cannot see
As fear is the unknown
Of what the light can be

Perpetual Notion

This system of the existing
Forever will it change
We must travel with it
Minds must learn to rearrange

A crossroad has come upon us
To transcend levels of the mind
To jump into dimensions
To find the clear inside our time

This system of the ever changing
It mirrors into all our lives
Forever will we find we're moved
Past a consciousness of mind

This is our great dilemma
That we for pride will not budge
Though we must loosen up our lives
To feel that falling from above

Propelling Existences

Always is there room for change
Nothing seen remains the same
Never does the well run dry
Human minds freed will fly
Never are we standing still
Nor ever do we lose the thrill
Of thinking into virgin ground
To climb onto a higher mound
Always will we be in motion
Never reliving the same notion
Forever will change run through
All of me and each of you
Forever may we search the end
Always will we find a bend

Align

One has to make a future happen
Our fears inhibit mental movement
With every word a step is placed
Into this path of life we stride
Each of us plays a part
Within this massive mechanism
One can speak a word of truth
That many kill without connection
Our fears inhibit future movement
While each of us wants better times
A time has come for monumental
Upon the steps of forward progress
A chance is lost to lose the past
If we don't walk out of this time
To join the true in our mind

Contents

CPSIA information can be obtained at www.ICGtesting.com
Printed in the USA
LVOW080409140412

277567LV00004B/3/P